The Unique World of
MITSUMASA ANNO

Selected Illustrations
1968-1977

Translated and adapted by Samuel Crowell Morse
with a foreword by Martin Gardner

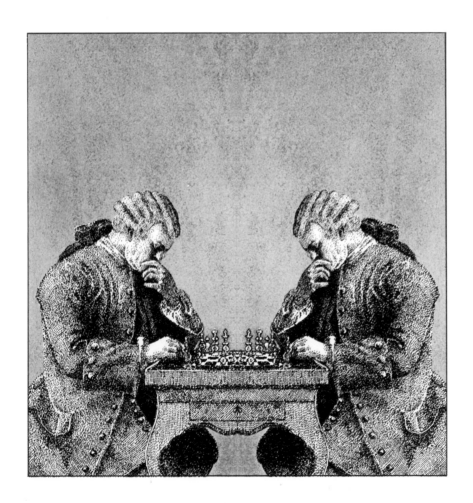

THE BODLEY HEAD
LONDON SYDNEY
TORONTO

Acknowledgments

The editors and publishers herewith render thanks to the following authors, publishers, and agents for permission to reprint copyrighted materials in this book. All possible care has been taken to trace the ownership of every selection included and to make full acknowledgment for its use. If any errors have accidently occurred, they will be corrected in subsequent editions, provided notification is sent to the publishers.

PAGE 7, caption for Plate 1: Copyright © 1979 by Freeman Dyson. Reprinted by permission of Harper & Row, Publishers.

PAGE 26, caption for Plate 20: Copyright © 1957 by Susanne K. Langer. Reprinted by permission of Charles Scribner's Sons.

PAGE 28, caption for Plate 22: From the FABLES OF LA FONTAINE translated by Marianne Moore. Copyright © 1952 by Marianne Moore, copyright renewed 1980 by Lawrence E. Brinn and Louise Crane. Reprinted by permission of Viking Penguin, Inc.

PAGE 31, caption for Plate 25: Copyright © 1948 by Kurt Seligmann. Reprinted by permission of Pantheon Books, a Division of Random House, Inc. (THE MIRROR OF MAGIC), and Penguin Books, Ltd. (MAGIC, SUPERNATURALISM AND RELIGION, Allen Lane, 1971).

PAGE 32, caption for Plate 26: GOETHE: SELECTED VERSE translated by David Luke. Harmondsworth: Penguin Books, 1964. Copyright © 1964 by David Luke. Reprinted by permission of Penguin Books, Ltd.

PAGE 37, caption for Plate 31: Copyright © 1953 by H. Allen Smith. Reprinted by permission of the Harold Matson Company, Inc.

PAGE 40, caption for Plate 34: Copyright © 1948 by Ray Bradbury, copyright renewed 1975 by Ray Bradbury. Originally appeared in Thrilling Wonder Stories. Reprinted by permission of the Harold Matson Company.

PAGE 41, caption for Plate 35: SAINT AUGUSTINE: CONFESSIONS, translated by R.S. Pine-Coffin. Harmondsworth: Penguin Books, 1961, pp. 78-79. Copyright © 1961 by R. S. Pine-Coffin. Reprinted by permission of Penguin Books, Ltd.

British Library Cataloguing in Publication Data

Anno, Mitsumasa
The unique world of Mitsumasa Anno.
1. Anno, Mitsumasa
I. Title
760'.092'4 N7359·A/

ISBN 0-370-30364-4

Original Japanese edition copyright © Kodansha, Ltd, 1977
International edition copyright © Kodansha, Ltd, 1980
All rights reserved
English language translation and special contents
of this volume copyright © 1980 by
Philomel Books, New York
Printed in Japan for
The Bodley Head Ltd,
9 Bow Street, London WC2E 7AL
First published in Japan by Kodansha, 1977
This shortened edition first published in
Great Britain 1980

CONTENTS

FOREWORD by Martin Gardner 4

Inscription on the Prison Gates by One
 Who Has Committed a Crime
 Against Art 6

THE PLATES

PLATE 1. *A Speculation on the Possibility
 that there might be Another Earth
 Somewhere Out There* 7

PLATE 2. *The Cantankerous Coffee Cup* 8

PLATE 3. *Jacta est Alea* 9

PLATE 4. *A Hammer-bird Toy* 10

PLATE 5. *The Myth of Sisyphus* 11

PLATE 6. *A Wooden Frame Without Tricks
 or Devices* 12

PLATE 7. *A Slightly Difficult Interlocking
 Wood Puzzle* 13

PLATE 8. *Patent Pending:
 An Impossible Approach to a Cup* 14

PLATE 9. *A Very Involved Conversation* 15

PLATE 10. *A Moonwatch* 16

PLATE 11. *I Am A Prisoner of My Thoughts* 17

PLATE 12. *The Endless Staircase* 18

PLATE 13. *Jirokichi, The Stripling Mouse* 19

PLATE 14. *The Wisdom of the System of
 Weights and Measures* 20

PLATE 15. *We Can Weigh Ourselves With the
 Scales We Use to Weigh Others* 21

PLATE 16. *A Tadpole is the Great-grandchild
 of a Wooden Spoon* 22

PLATE 17. *Pointu Counter Pointu* 23

PLATE 18. *The Outside of an Insideout Bottle
 is a Sea of Wine* 24

PLATE 19. *Wine is the Water of the Devil.
 No! Wine is the Blessing of Heaven* 25

PLATE 20. *Hourglass* 26

PLATE 21. *The Seven Implements of a Quack* 27

PLATE 22. *The "Belling the Cat" Problem, or
 Who Will Tie the Bell on the Cat?* 28

PLATE 23. *Entering a Maze* 29

PLATE 24. *This is a Knocker, But You Must
 Not Put it on the Bathroom Door* 30

PLATE 25. *The Key of Solomon* 31

PLATE 26. *Heidenröslein: The Rose on the
 Heath* 32

PLATE 27. *Multiplication Table* 33

PLATE 28. *If We Look at the Whole It is
 Wrong* 34

PLATE 29. *A Section of a Cube* 35

PLATE 30. *A River* 36

PLATE 31. *Anamorphosis* 37

PLATE 32. *The Life Cycle of a Matchstick* 38

PLATE 33. *Santa Fiammifero del Fiore, or
 The Three Little Pigs* 39

PLATE 34. *Where Might is Master, Justice is
 Servant* 40

PLATE 35. *Time Hides All* 41

PLATE 36. *Moonworld (Moon and Earth)* 42

PLATE 37. *A Pearapple* 43

PLATE 38. *The Leaning Tower of Pisa* 44

PLATE 39. *The Shadow of the Earth* 45

PLATE 40. *Will the Sun Rise Again?* 46

POSTSCRIPT by Mitsumasa Anno 47

FOREWORD

In the Western world 1980 could be *Anno Anno*, the year of Anno, the year that Mitsumasa Anno, former art teacher and now one of Japan's leading artists as well as a top book illustrator, ceases to be known only to a small group of devoted admirers.

Some Anno addicts claim to have discovered him as early as 1970 when his *Topsy-Turvies*, a fantastic book of "impossible pictures," became available outside Japan. Others were introduced to him during the next few years by such equally mind- and eye-dazzling books as *Upside-Downers*, *Maze*, *First Books of Mathematics*, *The Theory of Set*, *Dr. Anno's Magical Midnight Circus*, and *The Stone Brain Computer*.

My own discovery of his work came in the mid-seventies with *Anno's Alphabet*. So startling was this volume in its departure from the usual *ABC* book (A is for Apple, B is for Bear...), so filled with optical tricks and visual jokes, that I knew at once that a remarkable new artist was at work in Japan and that it would only be a matter of time until the world heard about him.

Anno's Counting Book came next, surely the most delightful book ever printed for introducing a small child to the meaning of the first twelve counting numbers. Then in 1978 there was pub-lished *Anno's Journey*, to me the most entrancing picture book for children in half a century. Most books of this kind have a life of about ten minutes, the time it takes to read the flimsy story once and glance at the pictures. There is no text at all in *Anno's Journey*, yet I cannot imagine an intelligent child or adult who will not return to the crowded illustrations again and again, each time discovering some new and wondrous detail. The following year brought us *Anno's Animals*, with its ingeniously hidden pictures, and a translation of *The King's Flower*, a gentle fable reminding us that big is not always beautiful.

His publishers now have given us the first collection of Anno's individual works of graphic art: *The Unique World of Mitsumasa Anno*. The book contains only a fraction of the artist's work during a ten-year period, pictures executed mainly to amuse himself and his friends, then offered to anyone of any age who enjoys representational art that plays with mathematics, science and paradox.

Of special interest, both to mathematicians and psychologists who study optical illusions, are Anno's "impossible figures." You'll find them on pages 9, 11, 12, 13, 18, 34, 35 and 40. Some of them are not perceived as impossible at first

glance. You may have to study carefully the wooden crate on page 12, and what seems to be a familiar "Chinese puzzle" on page 13, to see why they are impossible. The same is true of the curiously truncated cube on page 35. If a cube is sliced as shown, the cross-section has to be a hexagon. There is no way it can have an elliptical border. The illustrations on pages 11 and 18 are variations on what is sometimes called the "Escher staircase" because M.C. Escher used it in several of his pictures. Actually this marvelous illusion was invented by two British scientists, the geneticist L.S. Penrose and his physicist son, Roger.

The picture on page 37 is an example of what is called "anamorphic art." If you can't find a cylindrical can of the proper size, with metal sides that serve as a mirror, you can use a cylinder made by rolling up a sheet of mylar mirror paper (obtainable at any artists' supply house) and putting a rubber band around it to keep it from unrolling. Stand the paper cylinder on the circle. The reflection of Anno's picture, in the cylinder's side, will astonish you!

Anno's work has been likened to that of Escher and René Magritte, and there is something to be said for both comparisons. Like Escher, Anno is fascinated by geometry and optical illusions. Un-

like Escher he is not interested in unusual shapes that tesselate the plane, nor does he, like Escher, confine his work to black and white. He is more like Magritte in his use of color, his whimsical humor, his surrealistic juxtapositions of objects never seen together. He is, of course, no imitator of either artist. He is Anno, native of Japan, citizen of the world—a man at home with science and mathematics, knowledgeable about modern culture, seeing all things from his own subtle perspective.

Perhaps Anno's art is not for you. There are those who find Escher's pictures frigid and uninteresting. There are those to whom Magritte's paintings are no more than garish conundrums. I once met a modern artist, happily of short-lived fame, who assured me that Michelangelo's Sistine Chapel paintings were "overrated." *De gustibus non est disputandum*, said the wealthy art collector as he kissed his Rothko (w).

As for me, I am unashamed to count myself a member of the rapidly growing Anno cult. I am among those who find the future richer in potential visual pleasure because we do not yet know what amazements the skillful fingers of this pictorial prestidigitator will show us next.

MARTIN GARDNER

Inscription on the Prison Gates by One who has Committed a Crime against Art

As I pass through here, the laws of gravity fall into confusion.
As I pass through here, the needle of thought goes out of control.
As I pass through here without hope of pardon I arrive at the prison of art.

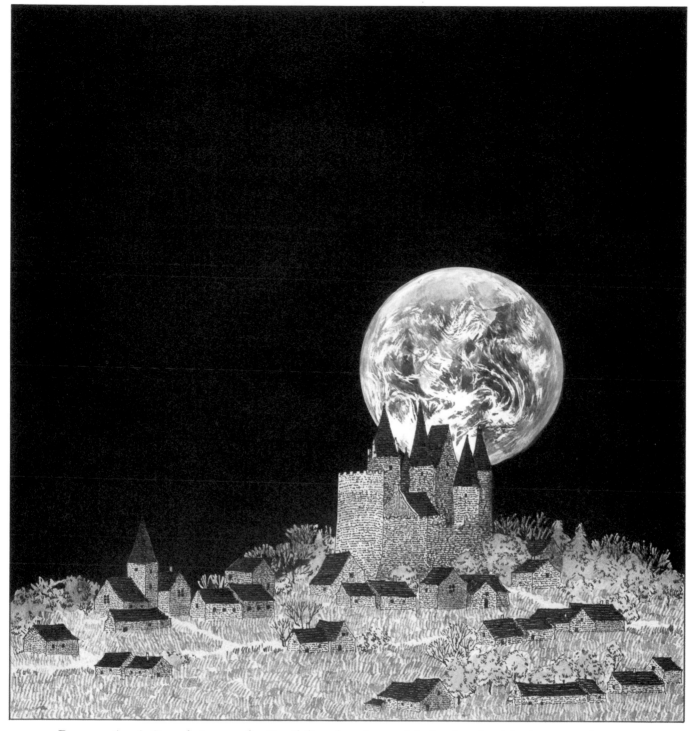

PLATE 1. *A Speculation on the Possibility that there might be Another Earth Somewhere Out There*

Before our expansion beyond the solar system begins, we must explore the galaxy thoroughly with our telescopes, and we must know enough about our neighbors to come to them as friends rather than as invaders. The universe is large enough to provide ample living space for all of us. But if, as seems equally probable, we are alone in our galaxy and have no intelligent neighbors, earth's life is still large enough in potentialities to fill every nook and cranny of the universe.

Freeman Dyson, *Disturbing the Universe.*

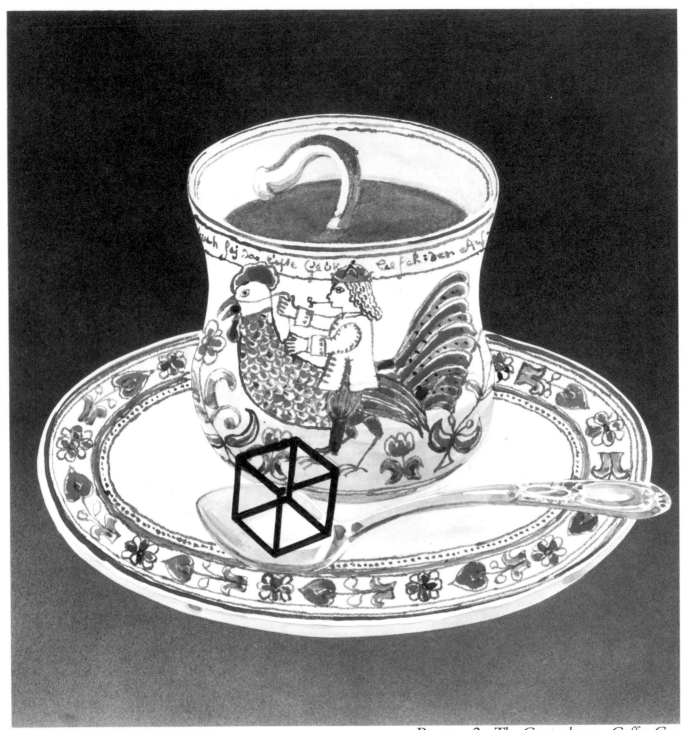

PLATE 2. *The Cantankerous Coffee Cup*

The first coffee tree was found in Arabia, and, in spite of the various transplantations that this shrub has undergone, the best coffee still comes from there.

An ancient tradition states that coffee was discovered by a shepherd, who noticed that his flock was in a particular state of excitement and gaiety whenever they browsed on the berries of the coffee tree.

Jean Anthelme Brillat-Savarin,
A Handbook of Gastronomy.

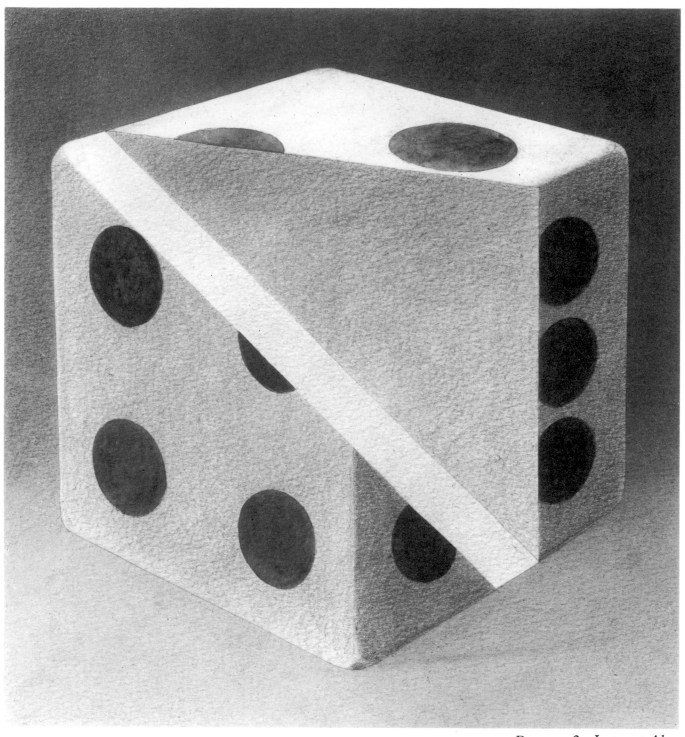

PLATE 3. *Jacta est Alea*

As he was passing a tent, Caesar heard a soldier facing the other players, engrossed in a game, say, "The die is cast."

The next morning when Caesar crossed the Rubicon with his army, the soldier's words of the night before came from Caesar's own mouth.

Shiono Nanao, *Cesare Borgia, or a Graceful Cruelty*. (Shinchō-sha).

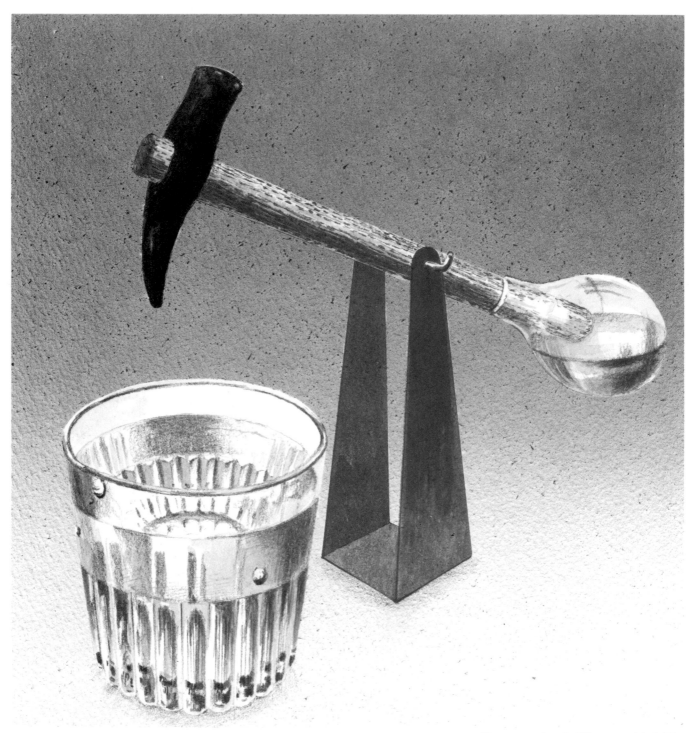

PLATE 4. *A Hammer-bird Toy*

The worship of science is no different from the belief in magic. That is because the feelings of worship which people have about science are rooted in their fears of a "power" they cannot understand. Their belief that magic and science are different depends on the vague notion that science is backed up by something rational.

Fujimura Jun, et al.
The Sources of 20th Century Science.
(Nippon hōsō shuppan kyōkai).

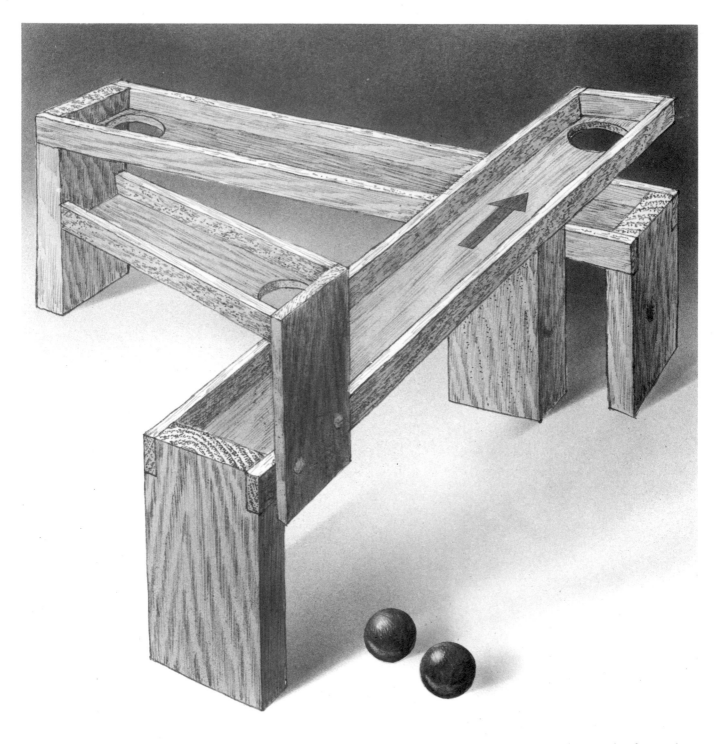

PLATE 5. *The Myth of Sisyphus*

When a body falls from a certain height it is able to perform work. That is to say, it possesses energy. Still, when it falls, if there is no friction, whatever path it takes, it attains a certain speed.

Conversely, if a body has a certain speed, it is able to climb to a certain height, and consequently when it falls, it is able to perform a certain amount of work.

Taketani Mitsuo, *An Introduction to Physics*. (Kisetsu-sha).

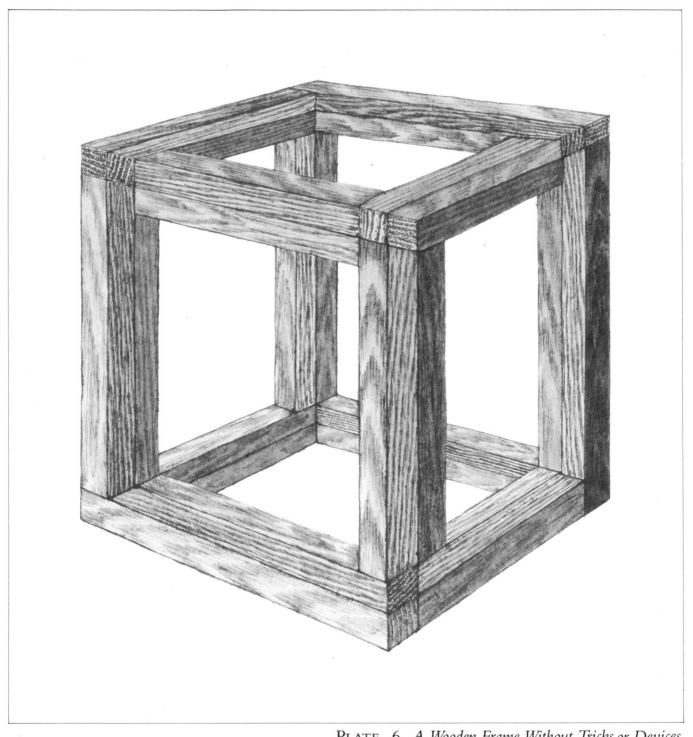

PLATE 6. *A Wooden Frame Without Tricks or Devices*

There are people in the world with distorted vision. (If you will forgive the expression). Referring to the cover of the July issue of *The Kagaku Asahi*, "Stonebrain's Joined Wood Frame," illustrated above, some said, "this is not merely an optical illusion; when you look at it from a certain point, it materializes as a fine three-dimensional form." Kaneda Masahiro who works in the printing office of the Ministry of Finance was one of these. He made a model out of wood and generously delivered it to our editorial office.

We have received similar observations from Satō Akihiro of Yokohama and Watanabe Satoshi of Fujisawa.

The Kagaku Asahi,
September, 1976.

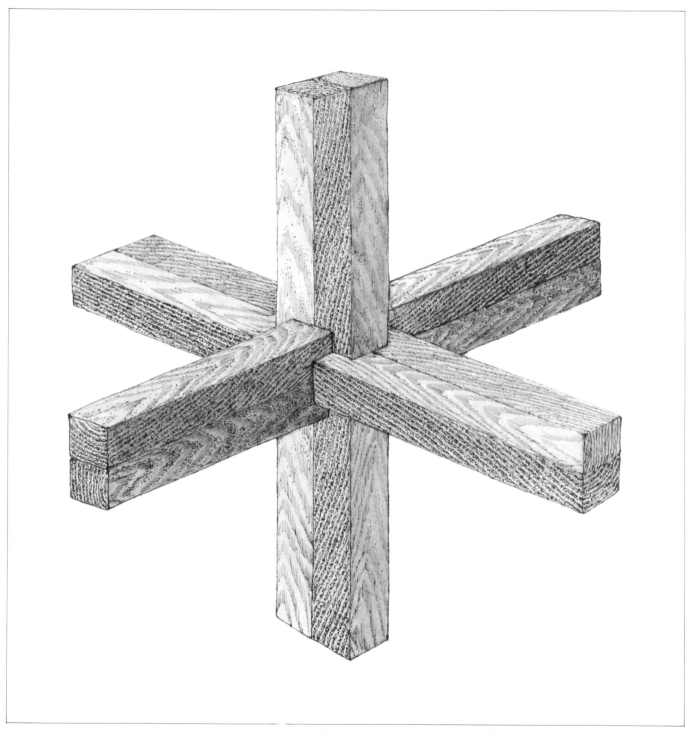

PLATE 7. *A Slightly Difficult Interlocking Wood Puzzle*

Rabelais: It is strange, but at the back of his consciousness, the quest for the *solution de continuité* always accompanies man. So perhaps, when I was drunk, I have written the wise words of a good demon without knowing it. Now, from this very *solution de continuité* all sorts of people, and consequently all sorts of truths are born. You do not understand this riddle, do you?

Watanabe Kazuo,
An Account of an Illusory Encounter.
(Chikuma shobō).

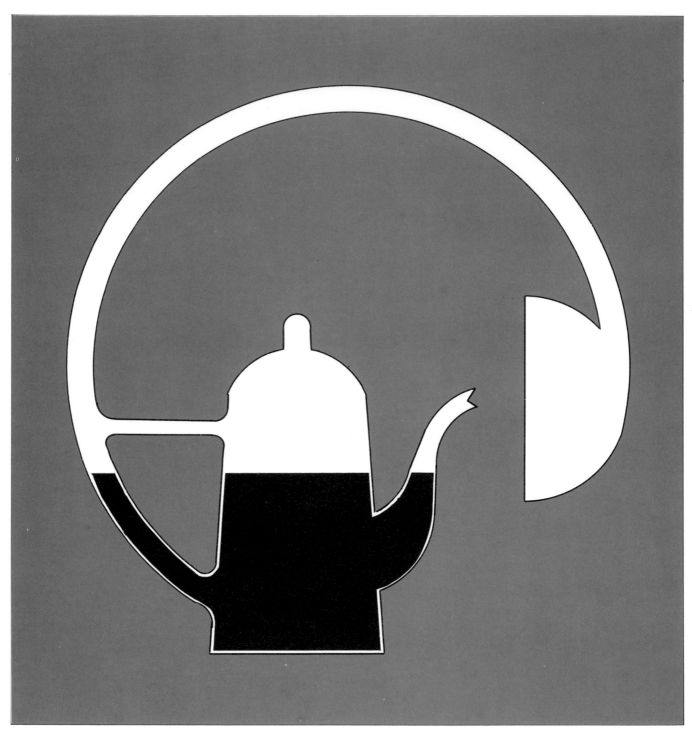

PLATE 8. *Patent Pending: An Impossible Approach to a Cup*

Often it is a single cylindrical shape which has a bottom but no top.

It is a hollow which stands directly upright. It is a restricted space sealed off from the center of gravity.

It can contain a certain volume of liquid without causing it to disperse within the gravitational field of the earth.

Tanikawa Shuntarō, *Definition.* (Shichō-sha).

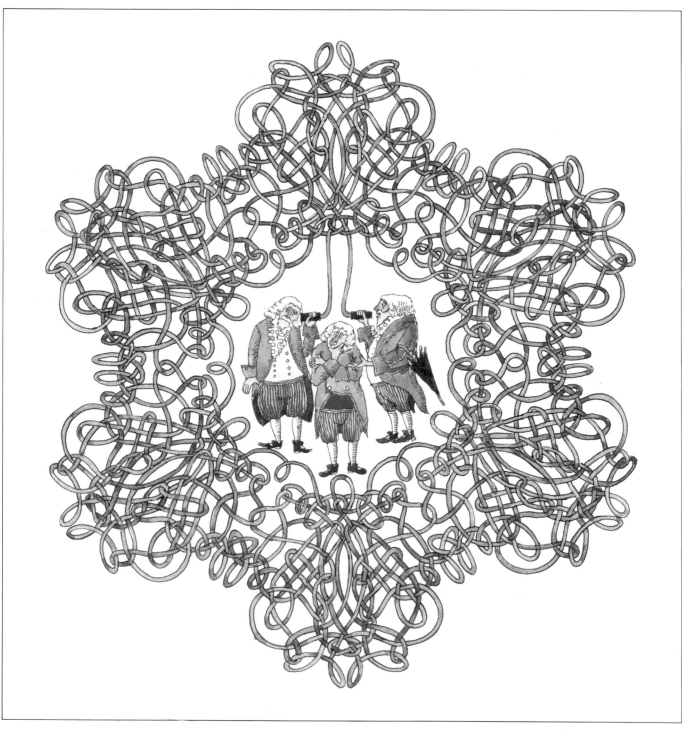

PLATE 9. *A Very Involved Conversation*

Telephone (n.) An invention of the devil which abrogates some of the advantages of making a disagreeable person keep his distance.

Telescope (n.) A device having a relation to the eye similar to that of the telephone to the ear, enabling distant objects to plague us with a multitude of needless details. Luckily it is unprovided with a bell summoning us to the sacrifice.

Ambrose Bierce,
The Devil's Dictionary.

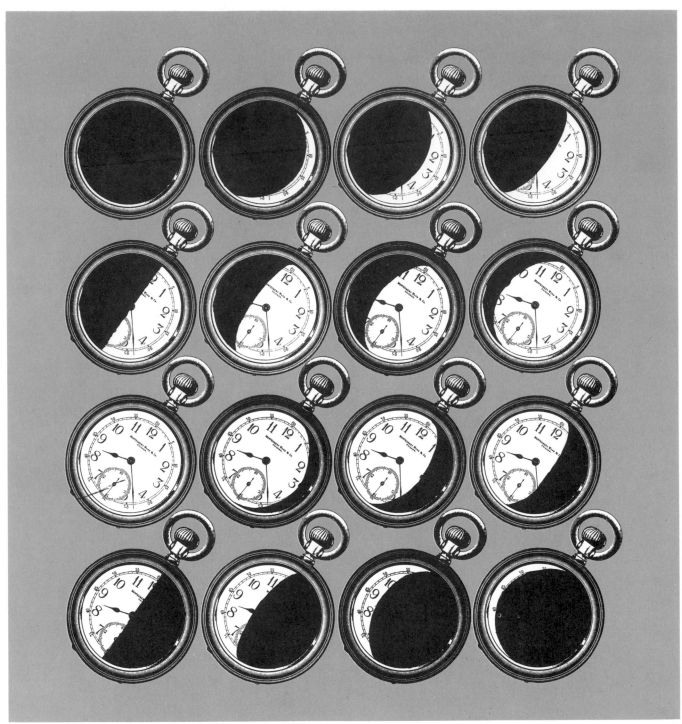

PLATE 10. *A Moonwatch*

ROMEO: Lady, by yonder blessed moon
 I swear
 That tips with silver all these
 fruit-tree tops,—
JULIET: O! Swear not by the moon, the
 inconstant moon,

That monthly changes in her
 circled orb,
Lest that thy love prove likewise
 variable.

William Shakespeare,
Romeo and Juliet,
Act 2, Scene 2.

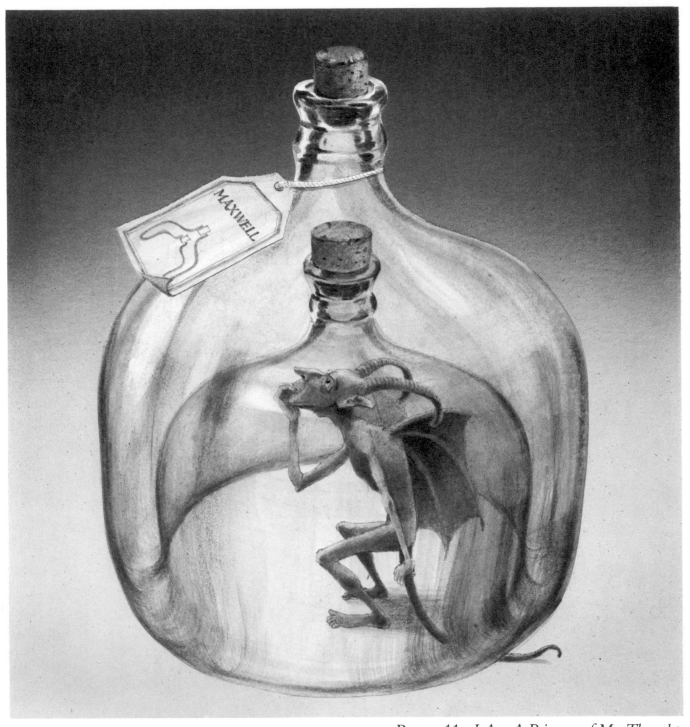

PLATE 11. *I Am A Prisoner of My Thoughts*

The reason that a Möbius strip gives one a strange sensation is that, conceptually, the distinction between "front and back" which ought to be clear has become ambiguous and vague; this phenomenon, however, can also occur with other dualities such as "inside and outside," "up and down," and "light and dark." ... Yet this violation of logic still permits us to say that such a world is formed by "representational truth."

The small devil wondering, "Am I inside the bottle or am I outside the bottle?" is concerned with this kind of "representational truth."

Nakahara Yūsuke,
The World of "Representational Truth."
(*The Chūō Kōron*, January 1977).

17

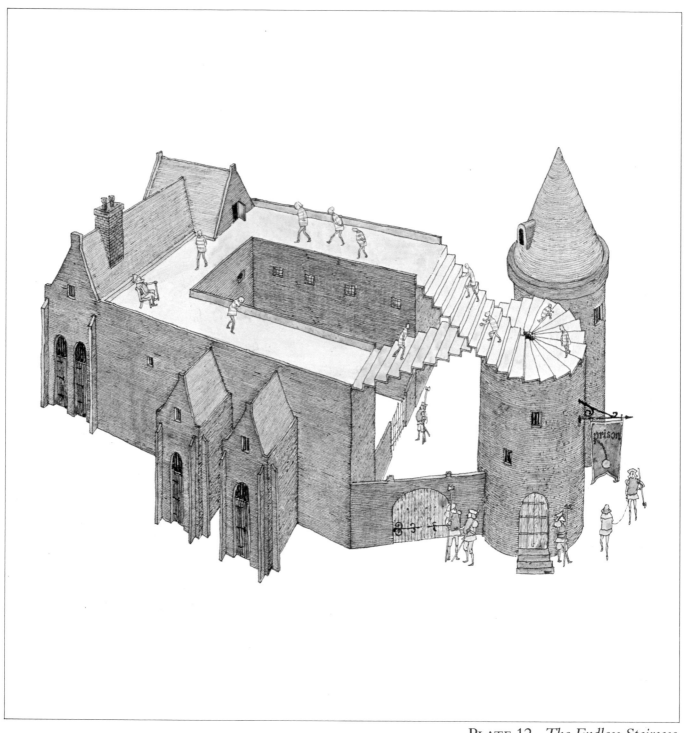

PLATE 12. *The Endless Staircase*

...Suffering is one very long moment. We cannot divide it by seasons. We can only record its moods, and chronicle their return. With us time itself does not progress...it revolves. This immobile quality, that makes each dreadful day in the very minutest detail like its brother, seems to communicate itself to those external forces, the very essence of whose existence is ceaseless change.

Oscar Wilde,
De Profundis.

18

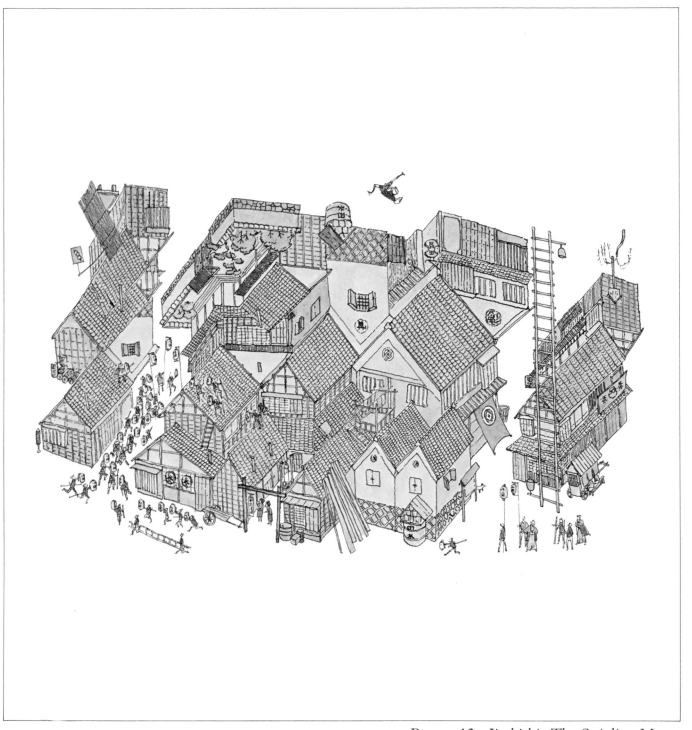

PLATE 13. *Jirokichi, The Stripling Mouse*

Jirokichi says, "Well, I apologize for visiting you in the middle of the night, but I am called the Stripling Mouse, who recently has been sneaking into the homes of the Daimyos in the residential part of town. Doubtless, this is a misdeed, but I want very much to help the unhappy farmers and townspeople. I do not use even the least bit of what I take for myself or for luxurious living. I need some money urgently, tonight, for a matter of life or death. I am sorry, but I must ask you to give me whatever money you have."

Jirokichi, The Stripling Mouse,
(a Robin Hood character). (Kōdansha). 19

PLATE 14. *The Wisdom of the System of Weights and Measures*

Although by using an electron microscope you can measure to within one hundred thousandth of a millimeter, you cannot measure anything smaller than that. No matter how much science progresses and machines develop, the refinement of measurement increases only gradually. Thus we can never understand the true value of some natural objects. This is inevitable and natural, as human beings can understand only what they are able to see.

Nakaya Ukichirō,
The Methods of Science.
(Iwanami shoten).

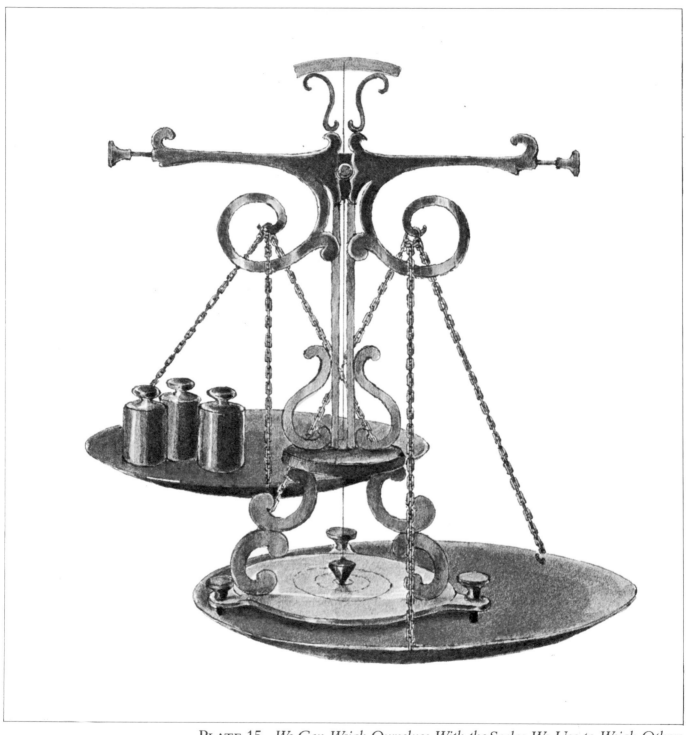

PLATE 15. *We Can Weigh Ourselves With the Scales We Use to Weigh Others*

Taste: that is weight at the same time, and scales and weigher; and alas for every living thing that would live without dispute about weight and scales and weigher!

Friedrich Nietzsche,
Thus Spake Zarathustra. 21

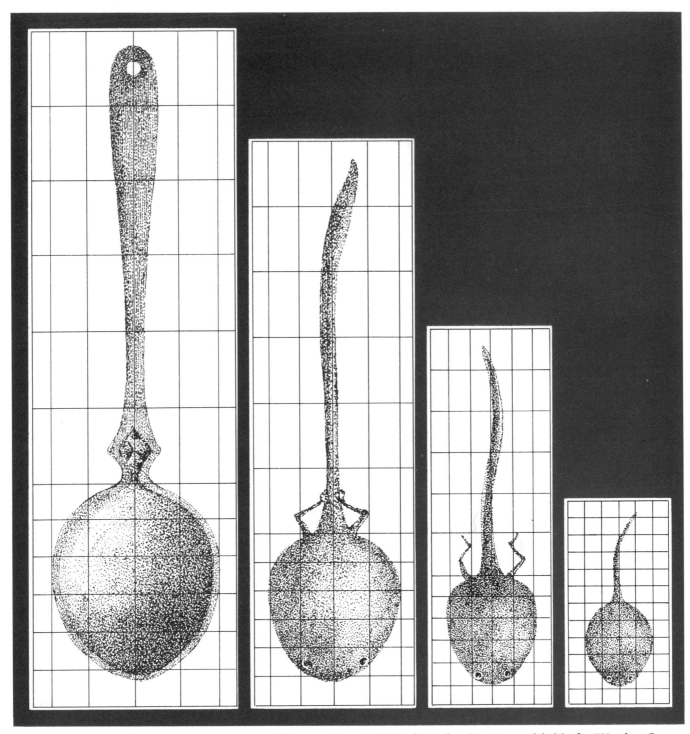

PLATE 16. *A Tadpole is the Great-grandchild of a Wooden Spoon*

Blackly, sadly, yet energetically,
Tadpoles dart about,
Are caught, become entangled
In the blue weeds, thin
And sharp as needles.

A pale blue, dead frog, belly up,
Floats on the surface of the water.
Light shines silver
All over its surface,
Like the momentary tolling of a bell.

This morning, smiling tearfully,
Flicking their thin tails as if in pain,
Tadpoles dart silently through the water,
Blackly, sadly, yet energetically.
Tadpoles?—my heart.

22 Kitahara Hakushū.

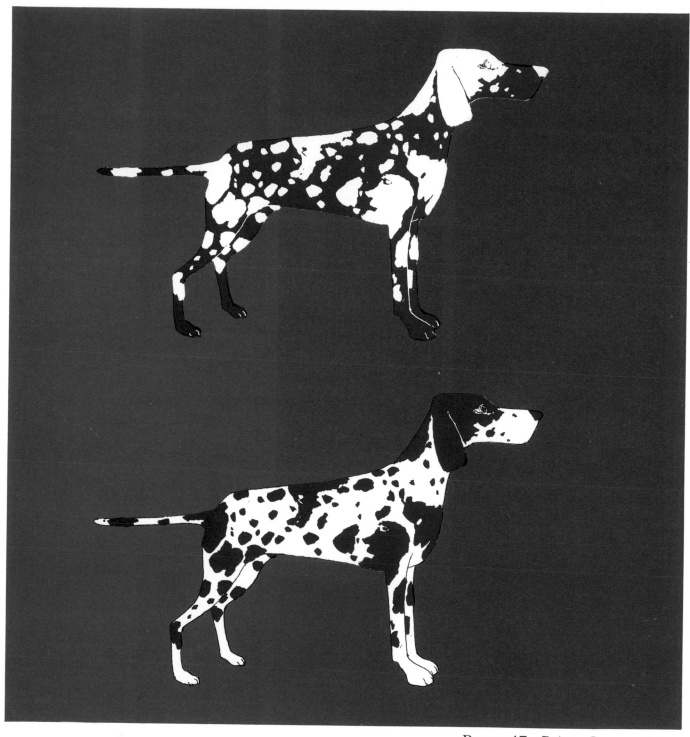

PLATE 17. *Pointu Counter Pointu*

One should not put Pointu outside in this weather; a sharp draft of cold air has already obliged him to forsake his own mat by the door and come to the fireplace. After circling in place for a long time, he has positioned himself practically on top of the hot coals, and now he refuses to move.

"Come, get away from there! How stupid you are!" we tell him. But he remains firm. And so, at the hour when the teeth of lost dogs are chattering in the cold, Pointu is comfortably warm and, although burning his tail and scorching his hair, he suppresses his desire to howl and smiles—with his eyes full of tears.

Jules Renard, *Histoires Naturelles.*

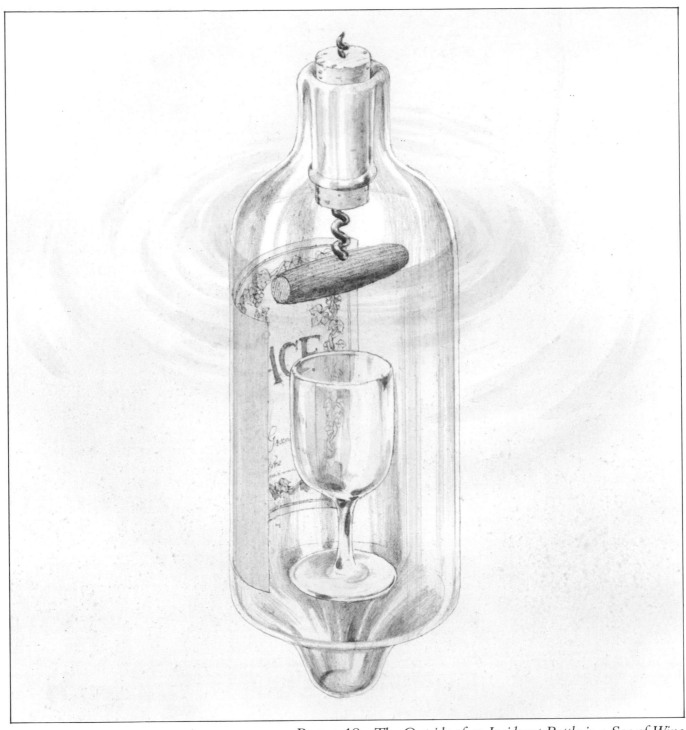

PLATE 18. *The Outside of an Insideout Bottle is a Sea of Wine*

"Molkte," the kind chairman advised him, "why do you drink so much? It is not good for you."

"Mr. Favell, I am not drinking because I like it. You may not be aware of it, but I have much to worry about and I am trying to drown my anxieties in drink."

"Does that work well?"

"It's no good. They are all such good swimmers they soon float back to the surface."

Collection of Humorous Jewish Stories.
(Neues Von Salgia Landmann).

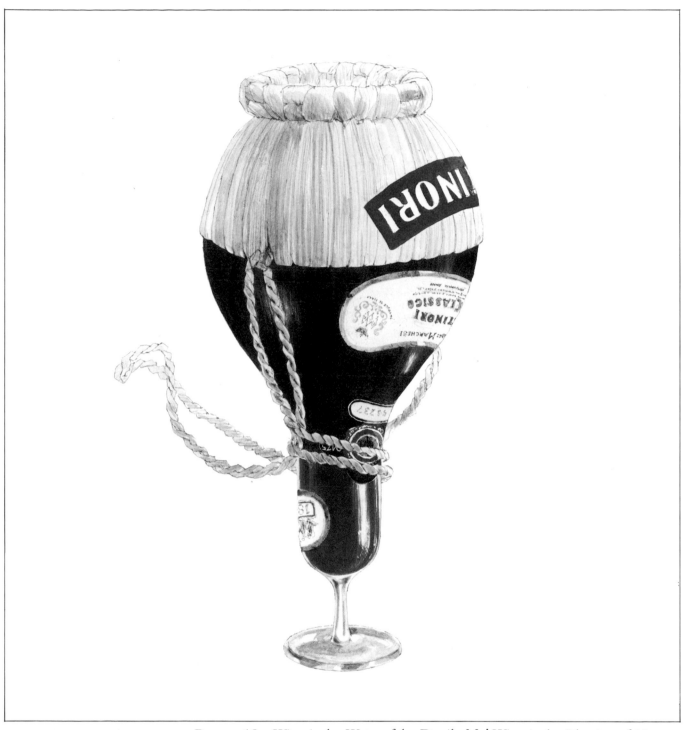

PLATE 19. *Wine is the Water of the Devil. No! Wine is the Blessing of Heaven*

Thou preparest a table before me
in the presence of mine enemies:
Thou anointest my head with oil;
my cup runneth over.

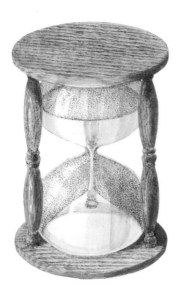

PLATE 20. *Hourglass*

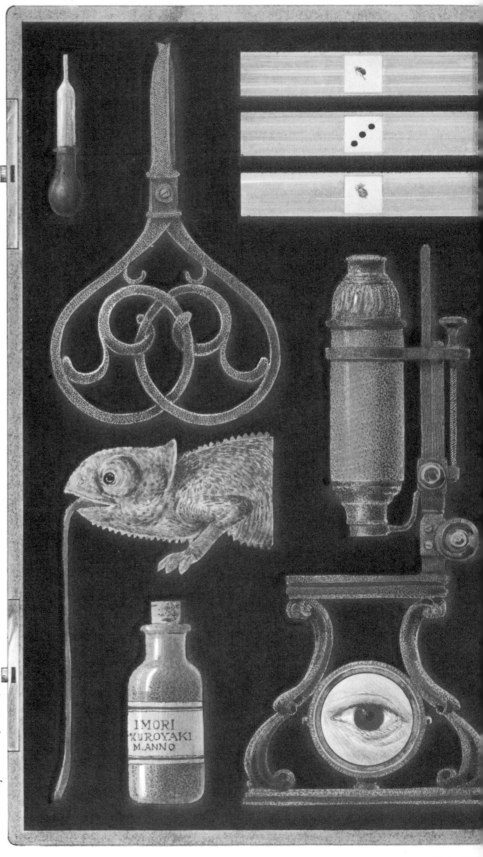

In painting, virtual space may be called the *primary* illusion, not because it is what the artist makes first, before he makes forms in it—it comes with the lines and colors, not before them—but because it is what is *always* created in a work of pictorial art.

Suzanne Langer, *Problems of Art,*
Ten Philosophical Lectures.

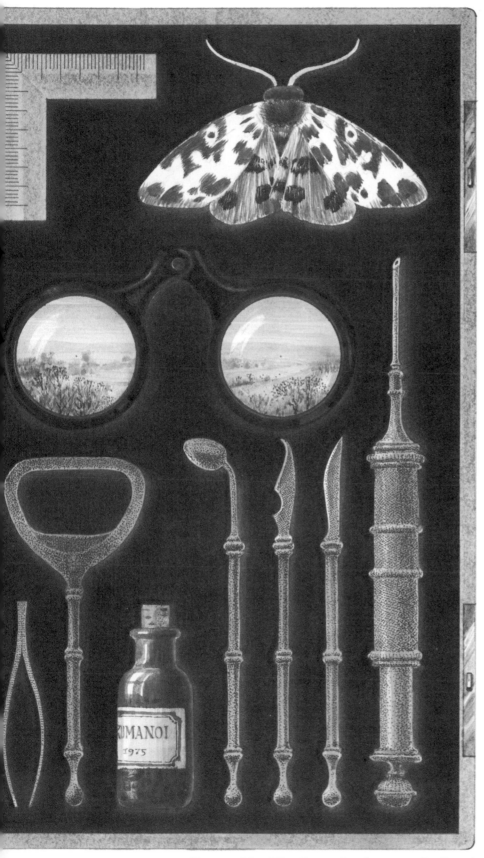

Physician (n.) One upon whom we set our hopes when ill and our dogs when well.

Ambrose Bierce,
The Devil's Dictionary.

PLATE 21. *The Seven Implements of a Quack*

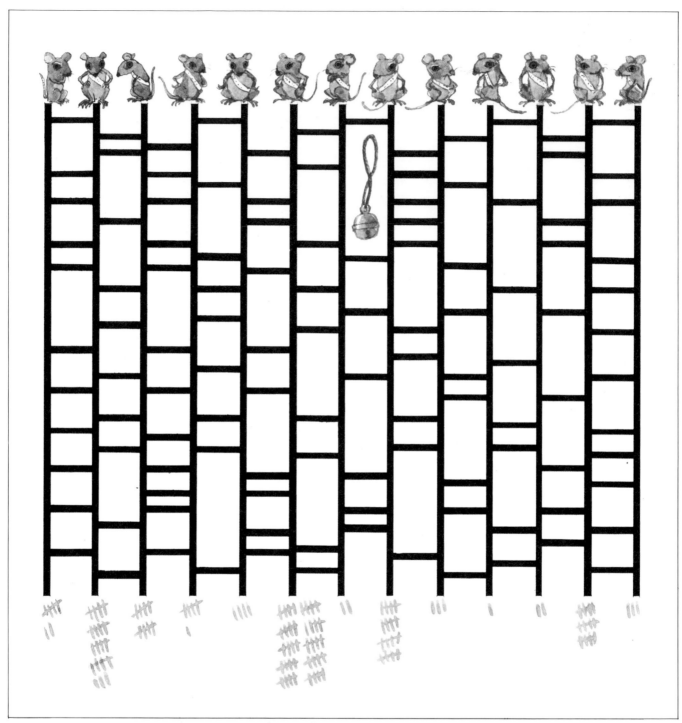

PLATE 22. *The "Belling the Cat" Problem, or Who Will Tie the Bell on the Cat?*

The problem was, which pair of paws should tie?
"This much is sure," said one. "I'm not the fool to
 try."
Another said, "Nor I." And since everyone
 seemed to cower,

All withdrew....
Concerned with points none need decide,
The courtroom swarms since all attend;
But when the cat's bell must be tied,
All flee on whom one might depend.

Marianne Moore,
The Fables of La Fontaine.

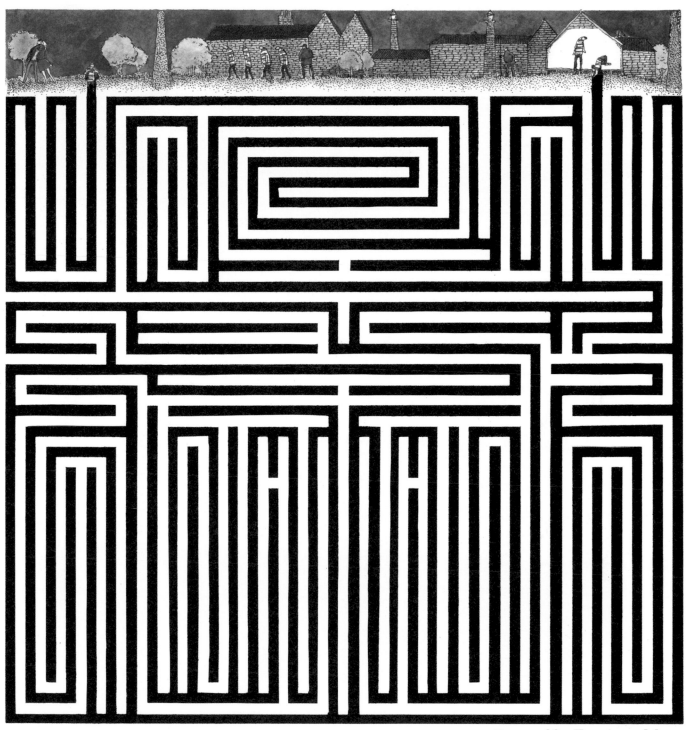

PLATE 23. *Entering a Maze*

"The corridor through which you have bored your way from the cell you occupy here extends in the same direction as the outer gallery, does it not?"

"It does."

"Well, then I will tell you what we must do. We must pierce through the corridor by making a side opening at about the middle, forming as it were the top part of a cross. This time you will lay your plans more accurately; we shall get out into the gallery you have described, kill the sentinel who guards it, and make our escape."

Alexander Dumas,
The Count of Monte Cristo. 29

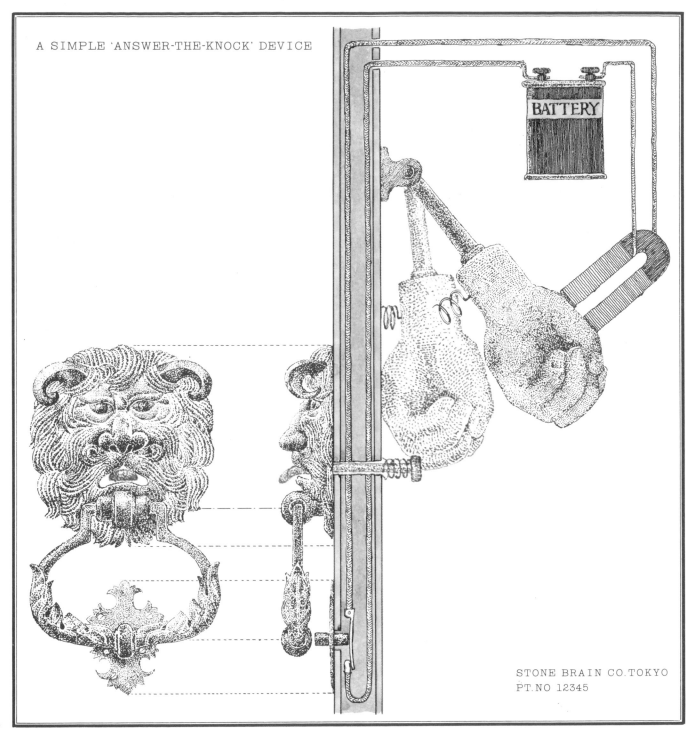

A SIMPLE 'ANSWER-THE-KNOCK' DEVICE

BATTERY

STONE BRAIN CO. TOKYO
PT. NO 12345

PLATE 24. *This is a Knocker, But You Must Not Put it on the Bathroom Door*

Ask and it shall be given you; seek and ye shall find;
Knock, and it shall be opened unto you:

For every one that asketh receiveth; and he that seeketh findeth;
and to him that knocketh it shall be opened.

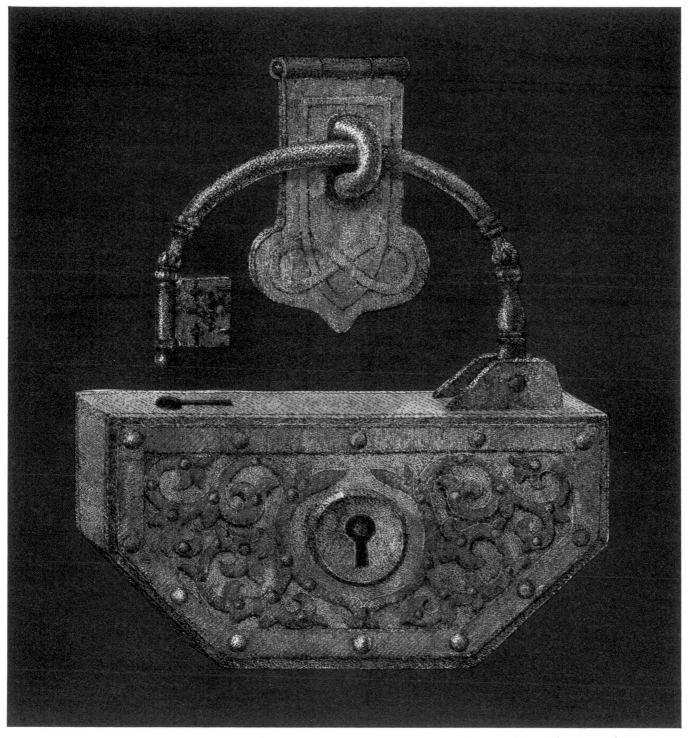

PLATE 25. *The Key of Solomon*

Come promptly, otherwise I will torment you eternally by the power of my mighty words and by the great "Key of Solomon," which he used when compelling the rebellious spirits to accept a pact. Thus appear as quickly as possible, or else I will torment you continuously by the words of the key: "*Aglon Tetagram Vaycheon Stimulamathon Erohares Retragsammathon Clyoran Icion Esition Existien Eryona Onera Erasyn Moyn Meffias Soter Emmanuel Sabaoth Adomai, I call you, Amen.*"

Kurt Seligmann, *The Mirror of Magic, A History of Magic in the Western World*

HEIDENRÖSLEIN

FRANZ SCHUBERT　　　　　*HEINRICH WERNER*

PLATE 26. *Heidenröslein: The Rose on the Heath*

A boy saw a rose growing,
A little rose on the heath;
It was so young and lovely as the morning:
Quickly he ran to see it from near,

And with much delight he saw it.
Rose, rose, little red rose,
Little rose on the heath.

Goethe, J.W., *Goethe: Selected Verse with an Introduction and Prose Translations by David Luke.*

| 0 | 1 | 2 | 3 | 4 | 5 | 6 | 7 | 8 | 9 |

PLATE 27. *Multiplication Table*

Multiplication is the art of easily distributing sums of the same number. When there are two different numbers one is called the multiplicand and the other is called the multiplier. By multiplying the two numbers we get the product. Their positions are always relative, and in reciting the multiplication tables you multiply the multiplicand by the multiplier to learn the answer.

Since the multiplication table is basic, it is most important to learn it well by heart.

Sugiyama Yoshitoshi, *New Writings on Eastern and Western Computation.* (Kōdansha).

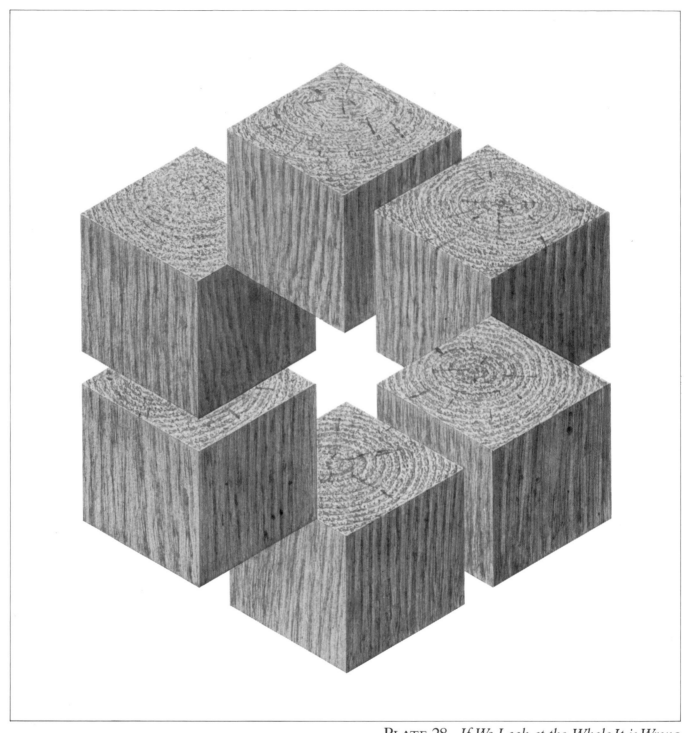

PLATE 28. *If We Look at the Whole It is Wrong*

The secret of this phenomenon arises from the fact that our eyes try to include, in the world of two-dimensional paintings, the sense of perspective usually employed in looking at our three-dimensional daily world. This is a game which cleverly reveals to us a blind spot of our intelligence. That which, because of its shape, is represented as far away, moves in front of something which is represented as near at hand. That relationship in other places reverses, so we become unable to distinguish which depth is correct.

Sakane Itsuo,
An Account of Recreational Science.
(Asahi shimbun-sha).

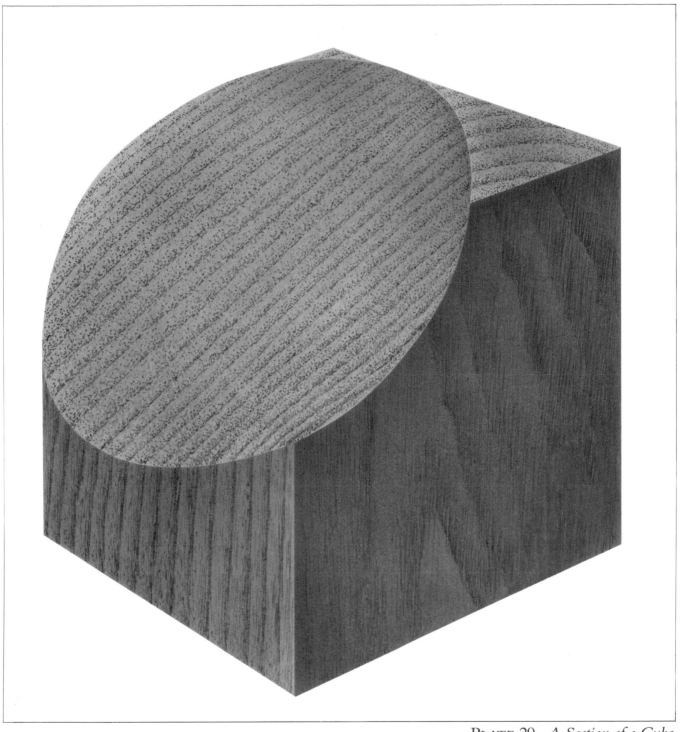

PLATE 29. *A Section of a Cube*

Even a round egg can become square according
 to how you cut it.
Even soft words, according to how you say
 them, can have sharp corners.

The mother of General Nogi liked this song, and
it is said that she always sang it after getting
slightly drunk in the evening. It is also said that
her daughter-in-law, Shizuko, did not like it, and
said that it was vulgar.

Minami Yōji,
One Hundred Years of Popular Songs
(Dorimu shuppan).

Waldseemüller, world map, 1507
Waldseemüller, Europe, 1511

Waldseemüller, Carta marina, 1516
Mercator, Palestine, 1537
Mercator, world map, 1538
Mercator, Flanders, 1540
Mercator, Europe, 1554
Mercator, British Isles, 1564
Mercator, world chart, 1569
Saxton, England and Wales, 1583
Plancius, world map, 1592
Plancius, world map, 1604
Blaeu, world map, 1605
Hondius, world map, 1608
Blaeu, world map, 1618

1
None; only a later
edition of 1520 is
known
1
1
2
1
1
3
4
2
1
1
1
1
1

To-day atlases are too commonly broken up by dealers, who can obtain better prices for the maps as separate sheets; this butchery has made many atlases, in their original form, needlessly scarce.

VIII. THE HISTORY OF MAP-COLLECTING

The taste for collecting and studying old maps, like other antiquities, may be justified by Dr Johnson's remark: 'Whatever withdraws us from the power of our senses, whatever makes the past, the distant, or the future predominate over the present, advances us in the dignity of thinking beings.' Yet map-making is a practical art, and Johnson himself advised King George III's librarian on the formation of the King's cabinet of contemporary maps and plans. It was as reference libraries of current or 'modern' cartography that many surviving collections of early maps were assembled by their founders.[1]

The Renaissance of the 15th and 16th centuries encouraged the cult of classical antiquity in Western Europe, where men began deliberately to search for and to preserve its relics. It was, however, not as an 'antique' but as a systematic representation of the contemporary world that the maps of Ptolemy were recovered, printed and acclaimed. The expansion of the known world by the great discoveries brought later cartographers a mass of new material, and their work was useful to geographers only if it was up-to-date. For the compilation of

[1] Yet even into these, maps already old found their way; for instance, the library of Pepys's patron William Legge, first Earl of Dartmouth, contained not only the drafts of Charles II's hydrographers and engineers, but also a chart by William Borough which was a hundred years older, and other Elizabethan military and naval sketches. The collection was dispersed by sale at Sotheby's on 9 March 1948; and the

PLATE 30. *A River*

"Thou seist that oxen, asses, hors, and houndes,
They been assayed at diverse stoundes;
Basyns, lavoures, er that men hem bye,
Spoones and stooles, and al swich housbondrye,
And so been pottes, clothes, and array;
But folk of wyves maken noon assay
Til they be wedded, —olde dotard shrewe!
And thanne, seistow, we wol oure vices shewe."

Chaucer, *The Canterbury Tales*,
"The Wife of Bath's Prologue,"
lines 282–291.

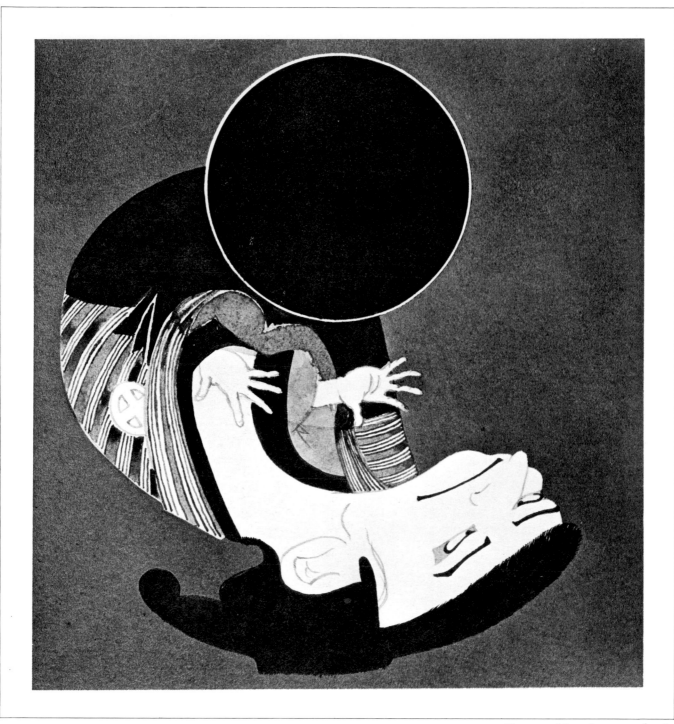

PLATE 31. *Anamorphosis*

(To see the anamorphic image, please place a shiny, cylindrical object (like a tea container) on the circle.)

...Hugh Troy...inserted an advertisement in the *Washington Post* as follows:

Too Busy to Paint? Call on
 THE GHOST ARTISTS
1426 33rd St., N.W. Phone MI. 2574
 WE PAINT IT YOU SIGN IT!
Primitive (Grandma Moses Type), Impressionist,
Modern, Cubist, Abstract, Sculpture...also
 WHY NOT GIVE AN EXHIBITION?

H. Allen Smith,
The Compleat Practical Joker.

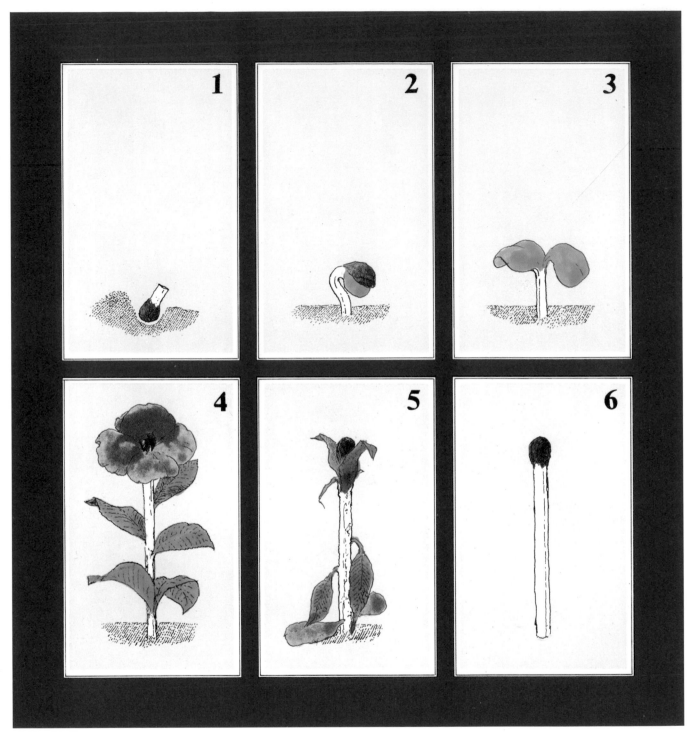

PLATE 32. *The Life Cycle of a Matchstick*

Of course the airplane was not discovered by putting wings and other things onto an automobile, nor did a submarine come into existence as a result of a boat gradually sinking into the water.

Hidaka Toshitaka,
The Conditions Under Which Animals Live.
(Tamagawa Daigaku shuppan bu).

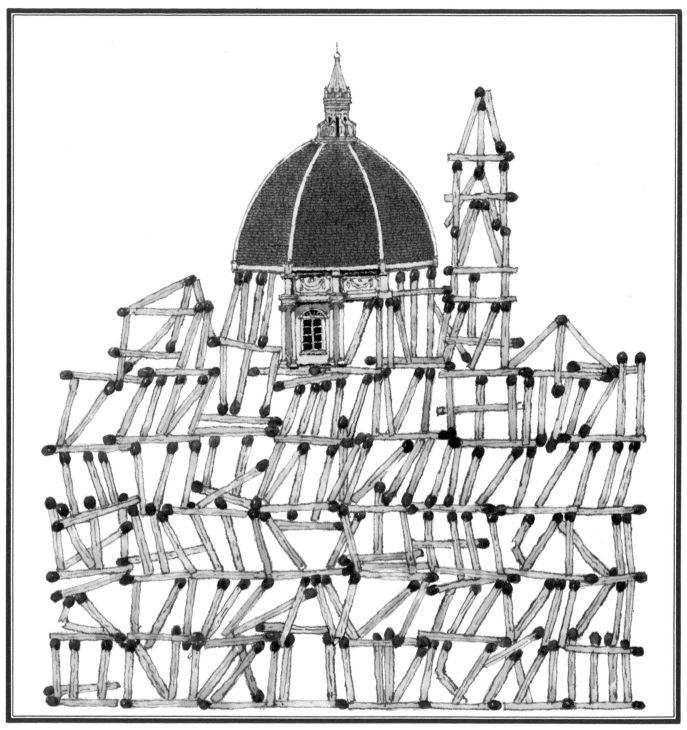

PLATE 33. *Santa Fiammifero del Fiore, or The Three Little Pigs*

The house of the second little pig was made of sticks. The wolf knocked on the door.

"Little pig, little pig, let me in, let me in!" he cried.

"Oh, no, Mr. Wolf. I will *not* let you in, not by the hair on my chinny-chin-chin," replied the little pig.

"Then I'll huff and I'll puff and I'll *blow* your house in!" roared the wolf. He took a deep breath and Huff! and Puff!—he blew with all his strength.

And the house of sticks, too, was blown away.

The Three Little Pigs. 39
Traditional English Folktale.

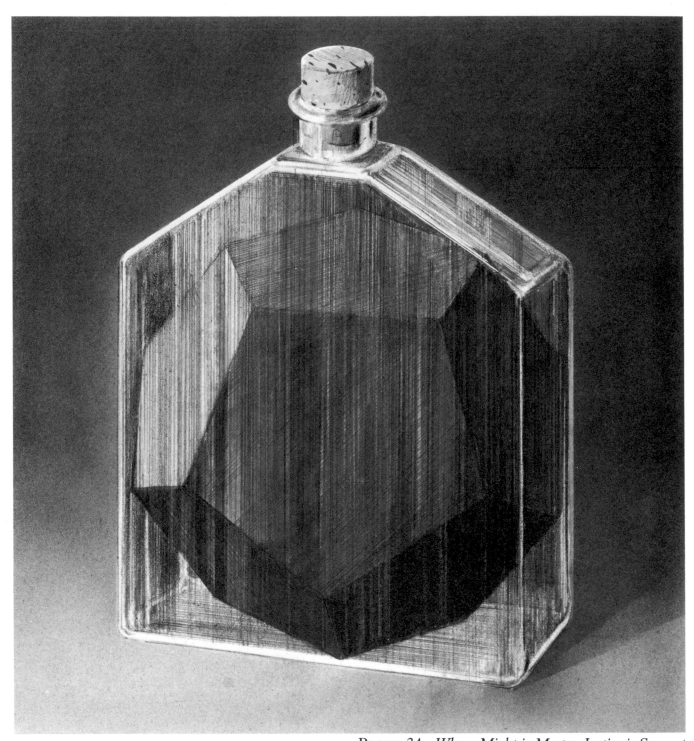

PLATE 34. *Where Might is Master, Justice is Servant*

"Centuries of thought have molded your atoms to your present form; if you could undermine and destroy that belief, the beliefs of your friends, teachers and parents, you could change form, be a pure referent, too! Like Freedom, Liberty, Humanity, or Time, Space and Justice!"

Ray Bradbury, *Thrilling Wonder Stories.*

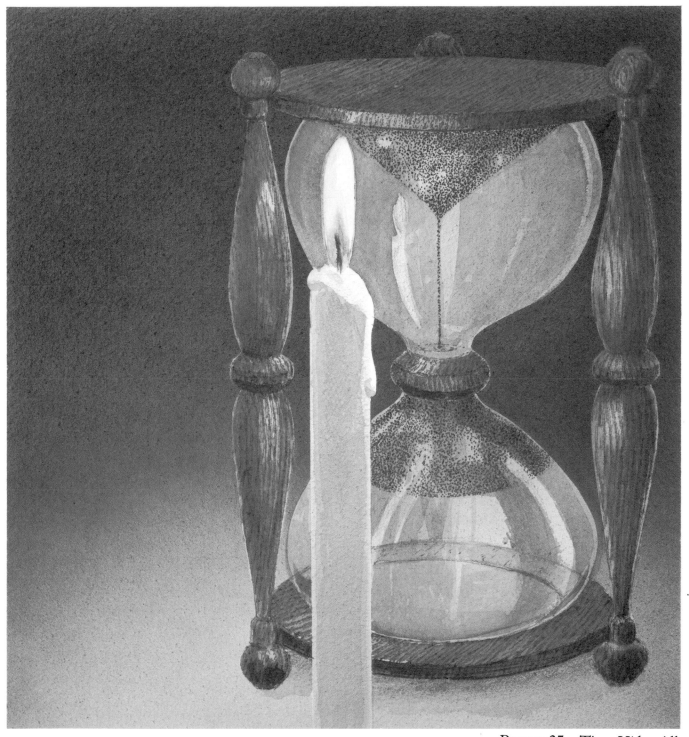

PLATE 35. *Time Hides All*

Time never stands still, nor does it idly pass without effect on our feelings or fail to work its wonders on the mind. It came and went day after day, and as it passed it filled me with fresh hope and new thoughts to remember. My sorrow gave way to them.

St. Augustine, *The Confessions*,
Book IV, Chapter 8. 41

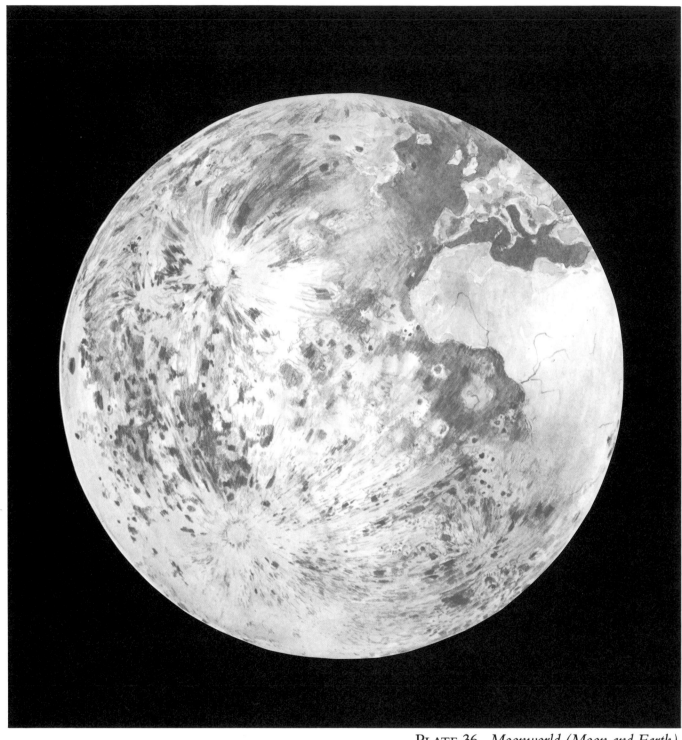

PLATE 36. *Moonworld (Moon and Earth)*

He insists that men could not be allowed by the Almighty to live there, since if they did they could not see Christ at his second coming descending through the air.

Andrew D. White, *A History of the Warfare of Science with Theology in Christendom.*

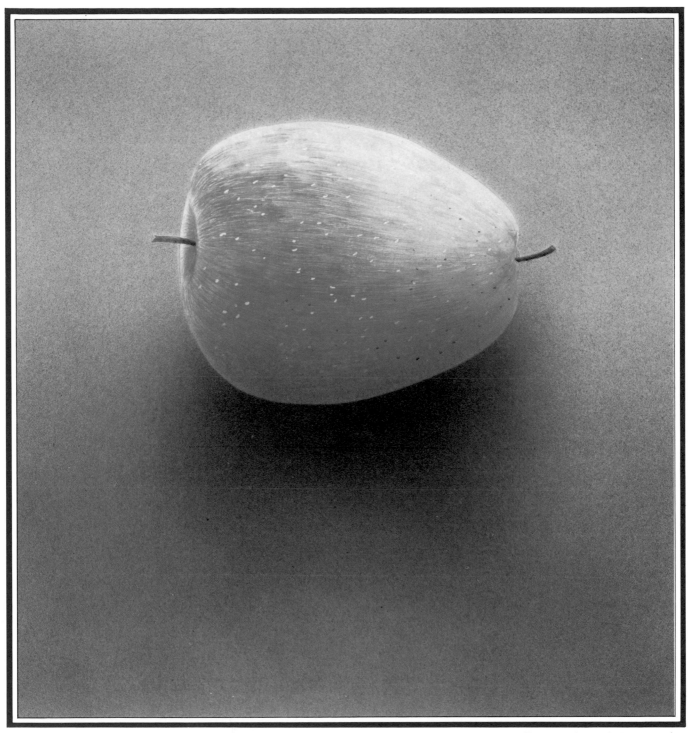

PLATE 37. *A Pearapple*

We cannot suppose that all breeds were suddenly produced as perfect and as useful as we now see them; indeed, in many cases, we know that this has not been their history. The key is man's power of accumulative selection: nature gives successive variations; man adds them up in certain directions useful to him. In this sense he may be said to have made for himself useful breeds.

Charles R. Darwin,
On the Origin of Species. Volume I.

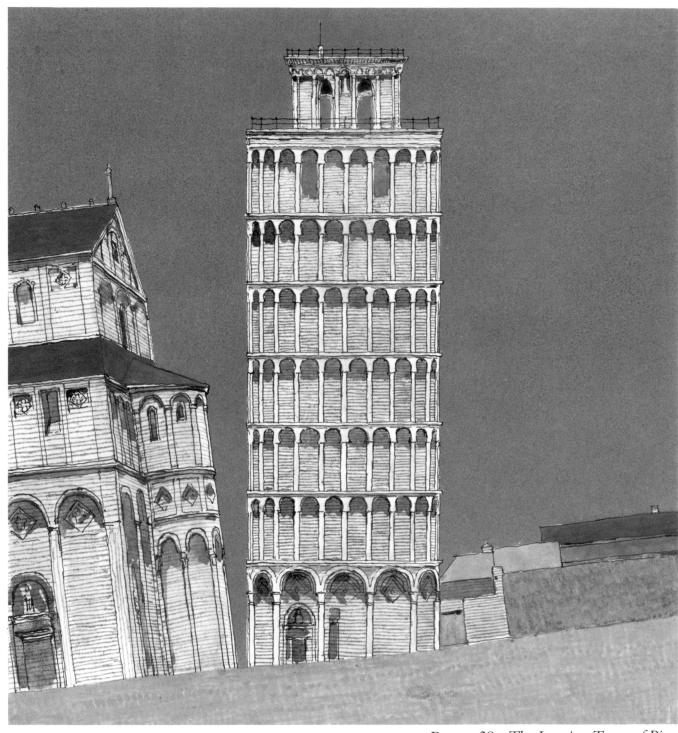

PLATE 38. *The Leaning Tower of Pisa*

Simplicio: Aristotle wrote that the velocity of a falling object is proportionate to that object's weight.

Salviati: Simplicio! If you acknowledge this as true, you must also believe that when you drop two cannon balls made of the same material, one weighing one hundred pounds and one weighing one pound, at the same instant from a height of one hundred cubits, the large cannon ball will have reached the ground while the small cannon ball has fallen only one cubit.

Galileo Galilei,
Le Opere Di Galileo Galilei.

PLATE 39. *The Shadow of the Earth*

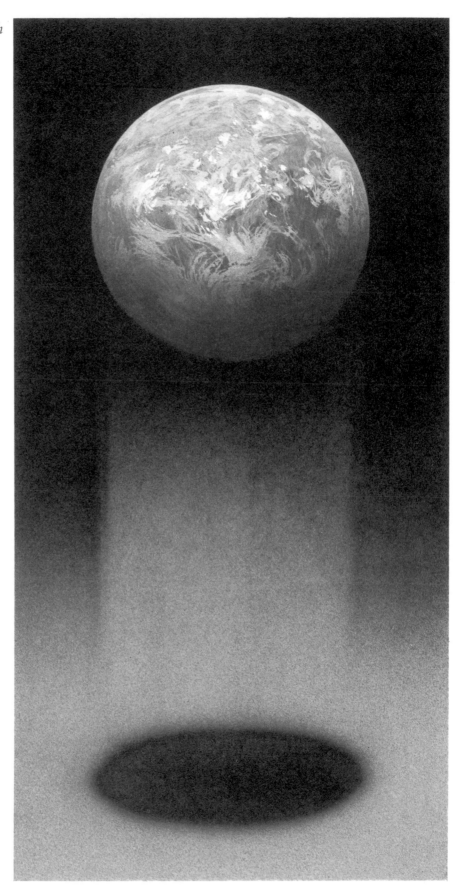

When an object is illuminated by the sun or by a light, it creates a shadow on the earth's surface or on the floor. What is important in this case is that although the object possesses three-dimensional mass, the shadow transferred to the surface becomes a two-dimensional outline. This is obvious; but the fact that "as an object becomes a shadow, one dimension of the object disappears" will be important for the development of our discussion.

Tsuzuki Takuji, *The World of the Fourth Dimension*. (Kōdansha).

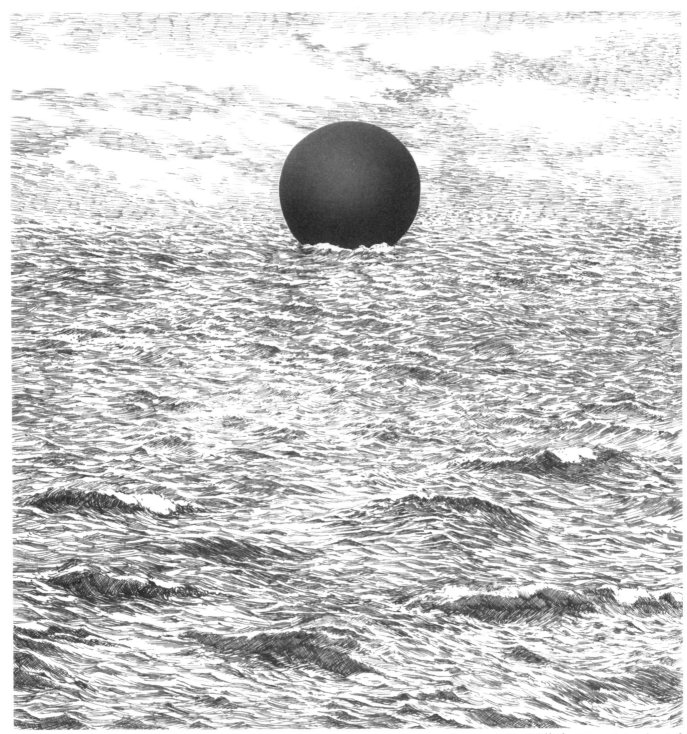

PLATE 40. *Will the Sun Rise Again?*

In a mediæval text-book, giving science the form
of a dialogue, occurs the following question and
answer: "Why is the sun so red in the evening?"
"Because he looketh down upon hell."

Andrew D. White, *A History of the
Warfare of Science with Theology in Christendom.*

POSTSCRIPT

Once someone said, upon seeing my pictures, "You amuse yourself by fooling people; you can't draw without a mischievous spirit."

I really wanted to counter by saying, "The spirit of noble humanity causes me to do so." If, however, I had to admit it, I should say that his words were correct. The more I think of playing tricks on my audience, the better I can concentrate power in my pictures.

My pictures are like maps, which perhaps only I can understand. Therefore, in following my maps there are some travellers who get lost. There are those who become angry when they discover they have been fooled; but there are also those who enter into the maze of my maps willingly, in an attempt to explore their accuracy for themselves.

* * *

Nakahara Yūsuke invented the phrase "representational truth" to express the logical appearance of the truth that is perceived by the eye, but which exists only in pictures and not in reality. In this case it is right to interpret the word "representational" as referring to an image, reflection, portrait, shadow, or vision.

Although in this world of "representational truth" the perspective method shows a two-dimensional picture of a three dimensional object or scene, this is not inconsistent. And if one looks at it "mathematically," it is quite perfect.

Centuries ago, the discovery of the perspective method brought about a great change in the history of painting; for a long time thereafter, this discovery dominated the general development of art; but the great artists of the modern age have tried to escape the restrictions of the perspective method and have succeeded in doing so. Escher, Dali, and Magritte, the elders of the Surrealist school, provided me with instructive examples and made it much easier for me to cast off those same bonds.

And as I freed myself of those bonds, I became aware of a new "representational truth," one which was subtly interwoven with futuristic ideas of topological geometry. Those who find it difficult to accept this concept might well consider the following example: "Because of the development of better transportation facilities, some parts of the United States and Europe have grown closer to Tokyo than remote parts of Japan." This example is no longer one of relative or even "representational" truth, but of reality itself.

If I were living in an earlier age my pictures would make people feel uncomfortable, and I might be condemned and severely penalized. Fortunately, today in what appears as an irrational and topsy-turvy world, my maps of what I perceive to be the universal realities do not seem to be so strange.

* * *

My kind of picture is difficult to explain verbally, and when one gives an explanation, the words seem to become trite. However, since there are those who may expect more from a book than a mere series of pictures, I decided instead of explanations, to quote relevant passages from the works of famous authors and to place the pictures with them.

There is an immeasurable distance between the

pictures and the quotations but also a delicate relationship exists due to their juxtaposition. Through this delicate relationship I can express curious feelings which could not be expressed in words alone or pictures alone.

I want to extend my heartfelt thanks to the authors and publishers of the passages I have chosen who very kindly gave permission for their use. As for the titles of the pictures, I was asked to include them by way of explanation. I deliberately wrote them, however, in enigmatic form to make them difficult to read. I hope thus to allow the reader to experience something similar to the puzzles that exist in my own thoughts, as they decipher the titles.

For those of you who see this book, I want to express my thanks to Muramatsu Takeji of the magazine *Mathematical Science*, who has published on its covers many of the paintings that now appear herein; and especially to Morita Eiji who edited this present volume and who listened to all my selfish requests; and also to all the other people who were connected with its publication.

—M. A.
October 1, 1977

I would like to offer my sincere thanks to Mr. Martin Gardner, whom I respect very much and who kindly provided a foreword for this international edition. This foreword alone gives the publication much value.

—M. A.
March 3, 1980